Copyright © 2018 By Claire Nicholson -

All rights reserved. Without limiting the rights under copyright reserved above, no part of this publication is reproduced, stored in or introduced into a retrieval system, or transmitted in any form, or by any means (electronic, mechanical, photocopying, recording or otherwise) without the prior written permission of both the copyright owner and the publisher of this book.

About the Author

Working with the children has been a life-changing experience, being a mother is a great gift. Teaching the young ones to understand the beautiful nature around them is my passion.
I am Claire Nicholson

About the Book

This is a colouring book for all ages especially the Kids. This shows different animals in action while playing football putting on different popular European Football Club jerseys. This book shows that regardless of the colours, structures, cultural beliefs, individual differences. We all speak Football.

To Kirsty, Dean and the children of the world as they learn about the fascinating world of animals.

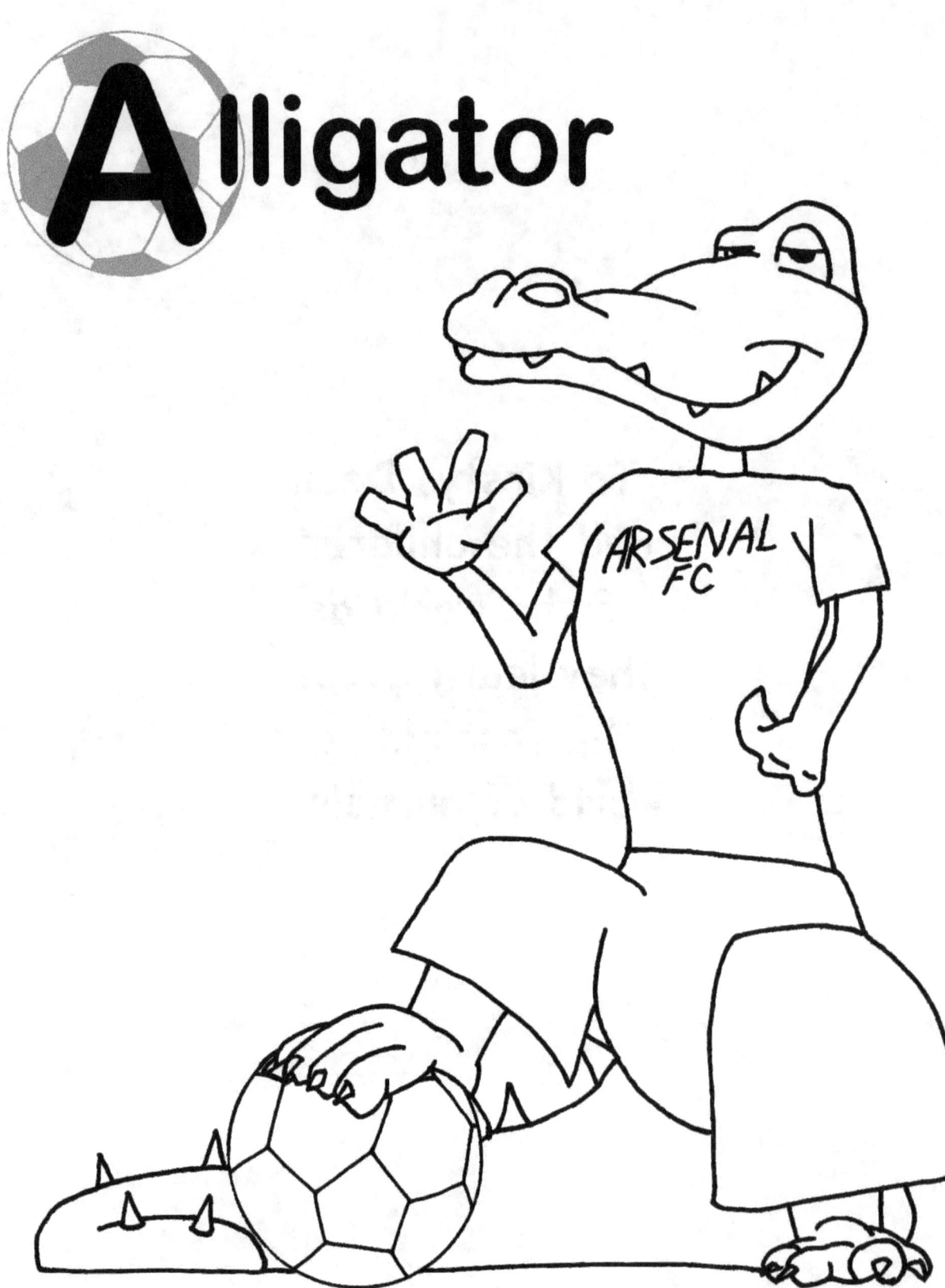

Bear

Chimpanzee

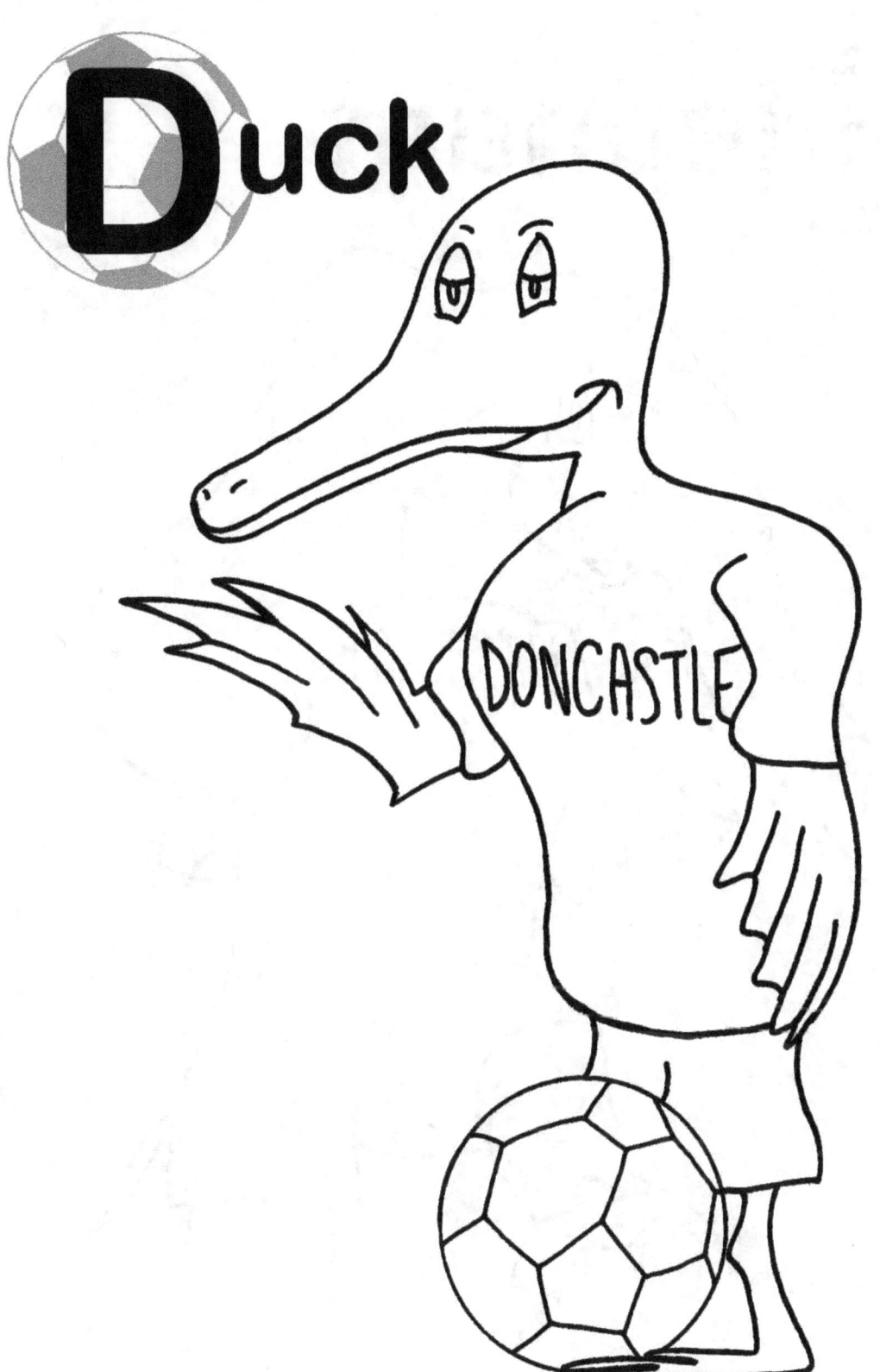

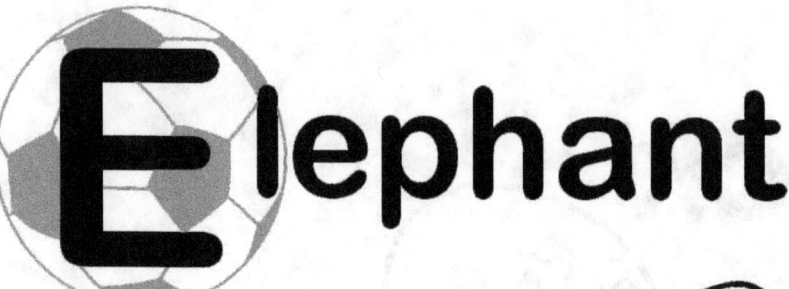

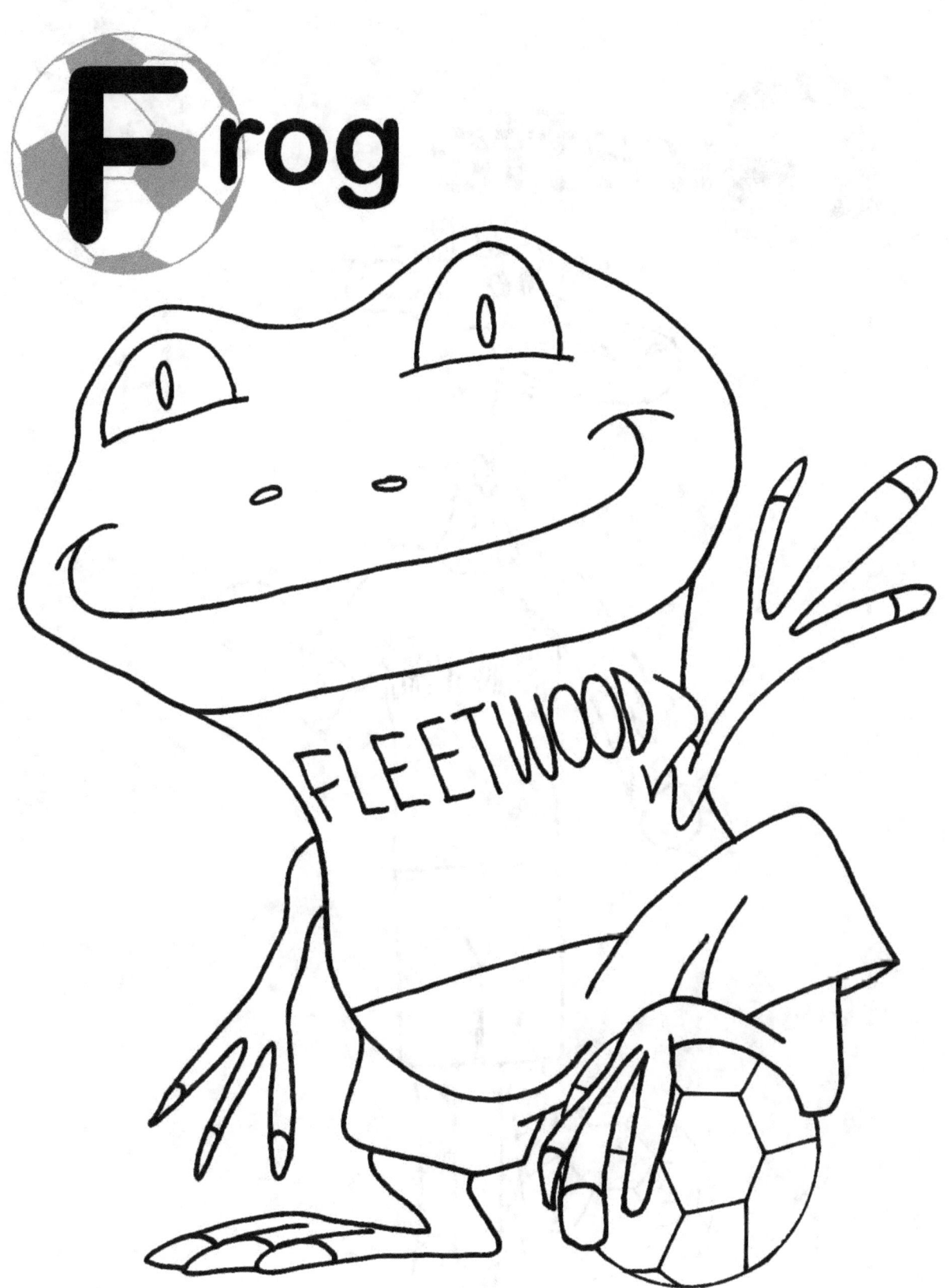

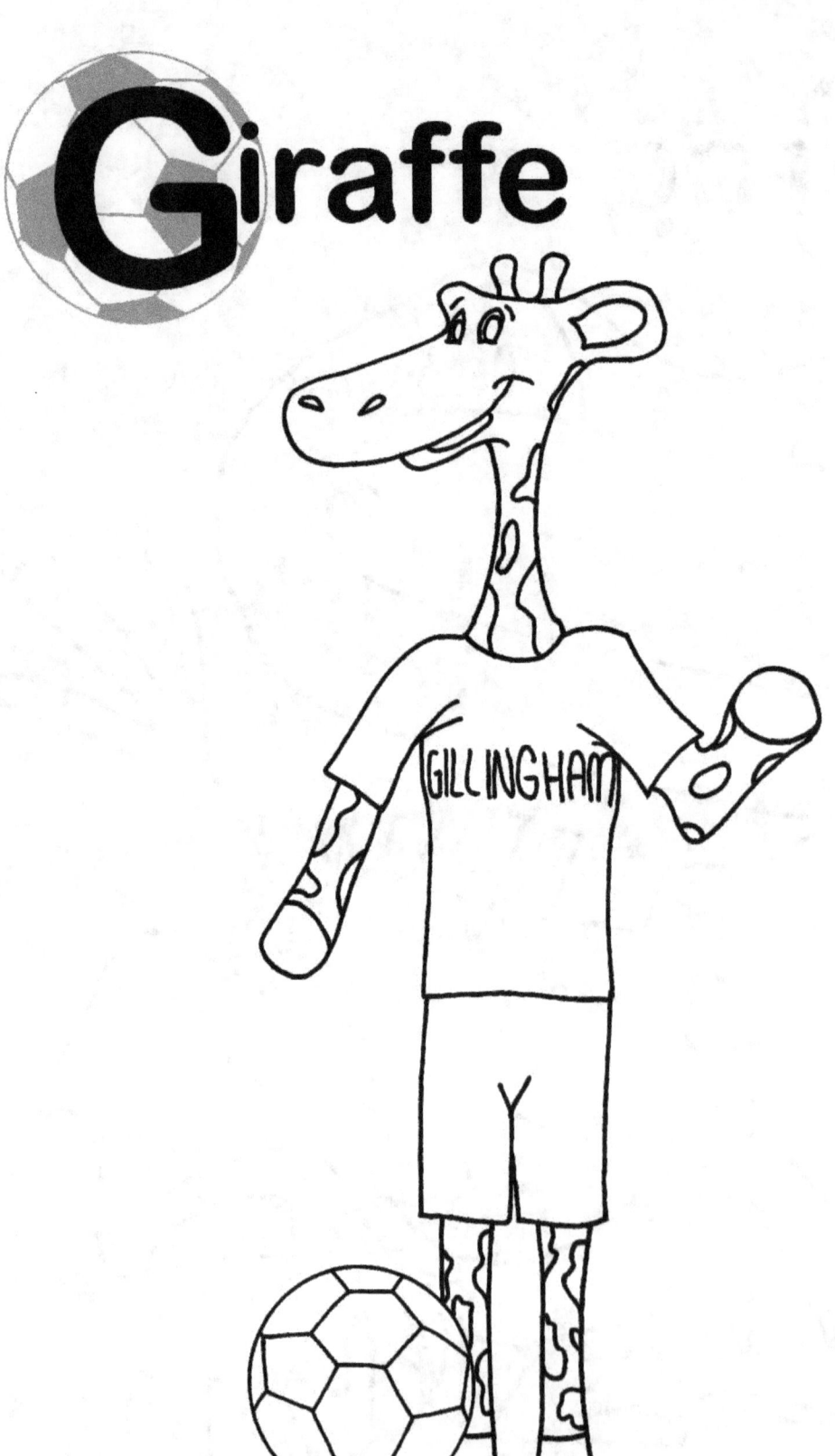

Hippopotamus

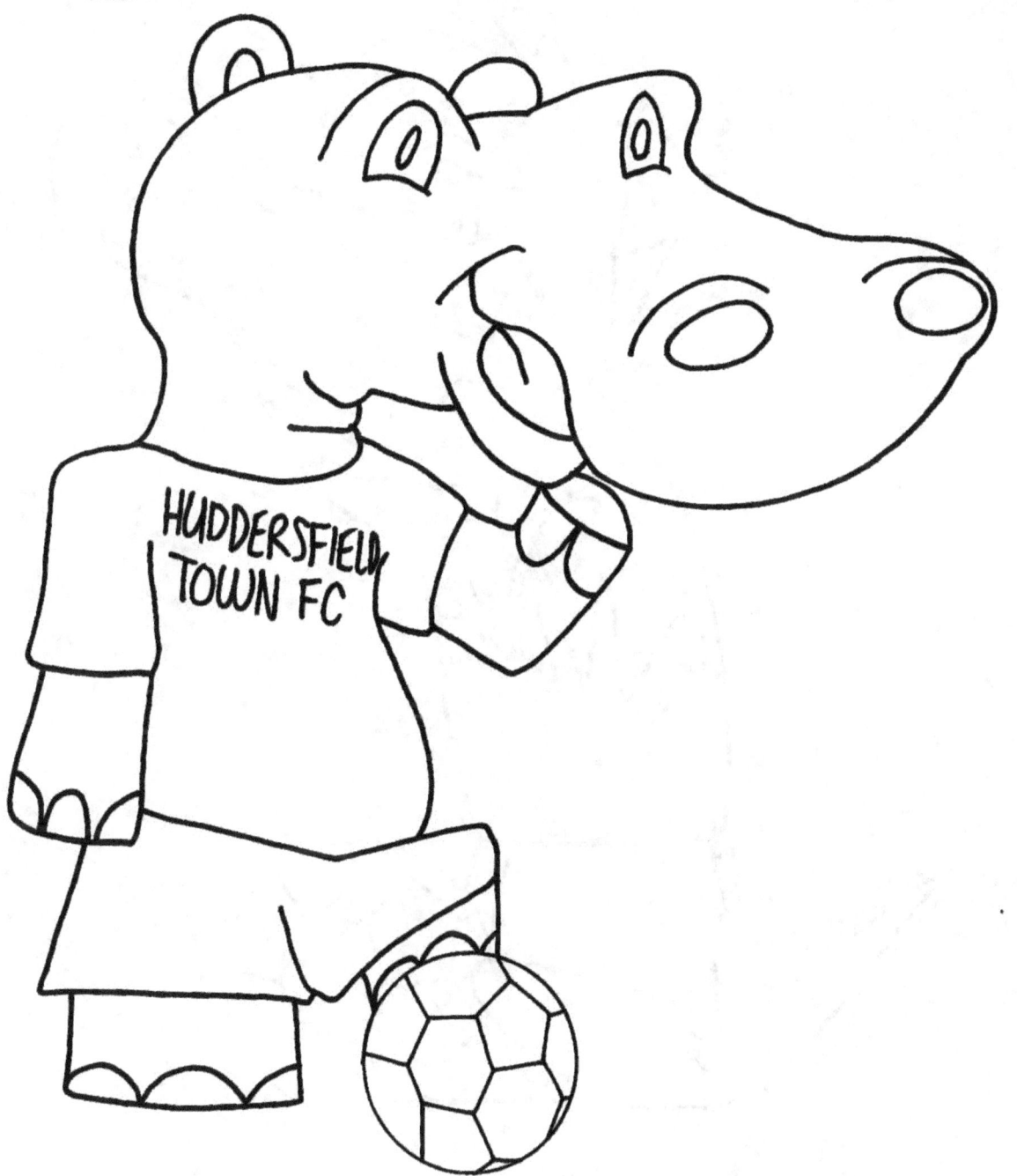

Iguana

Jellyfish

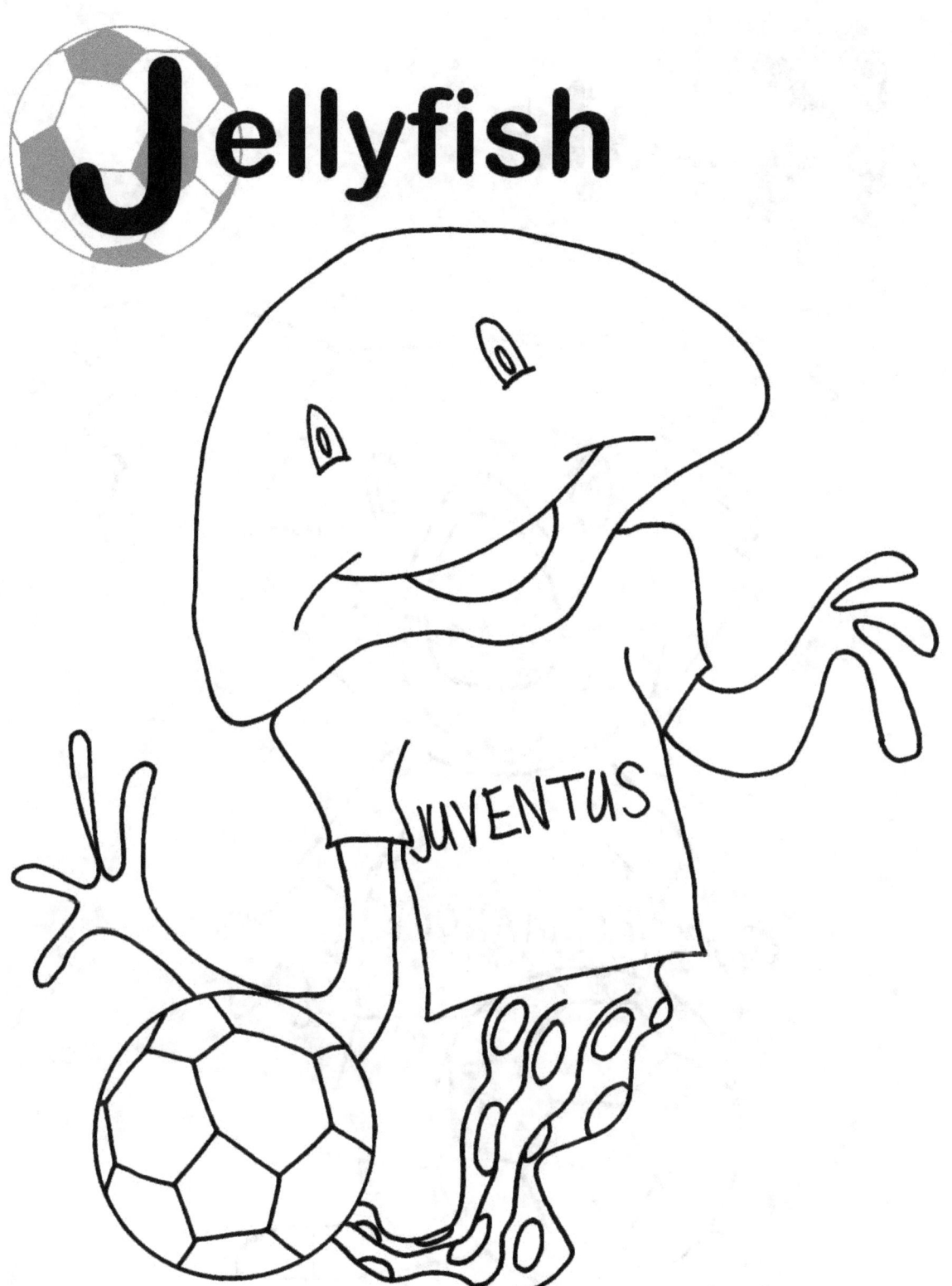

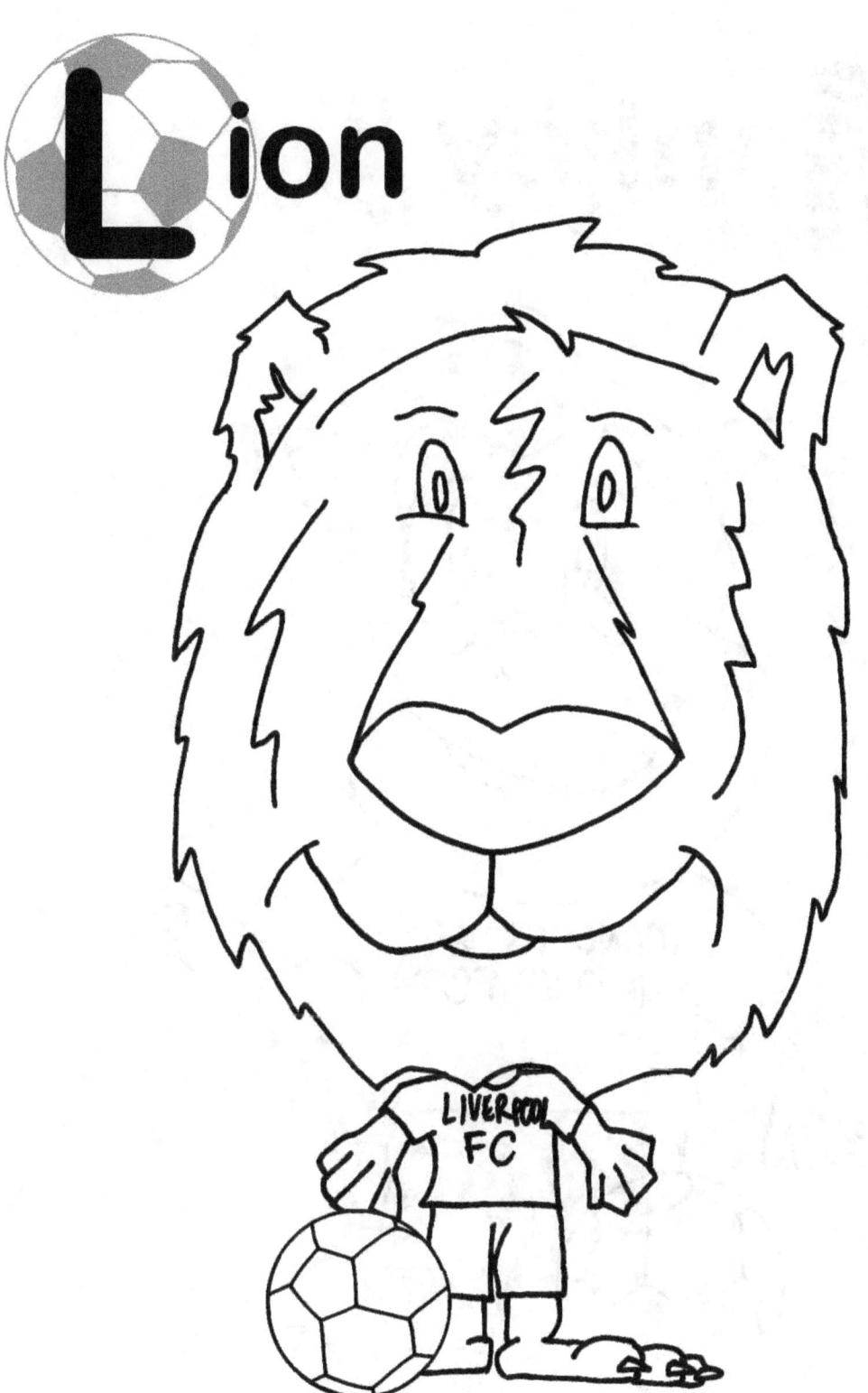

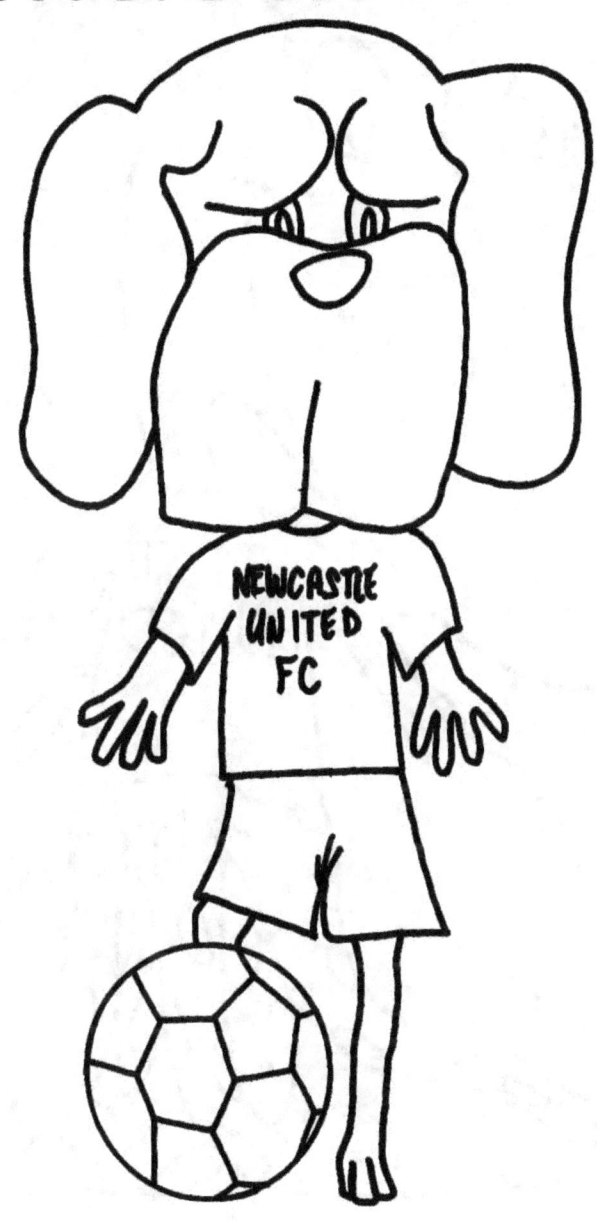

Octopus

Pig

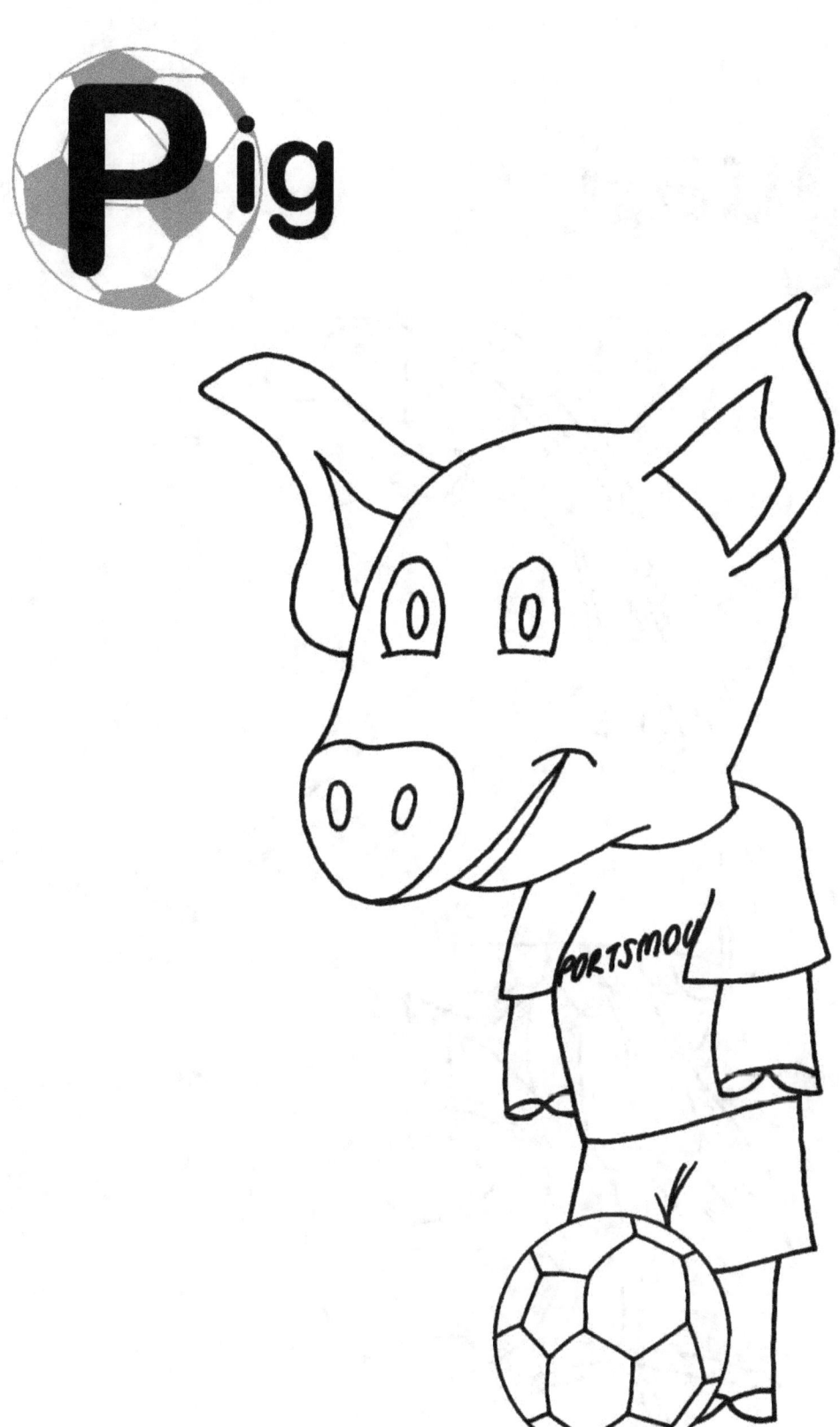

Quail

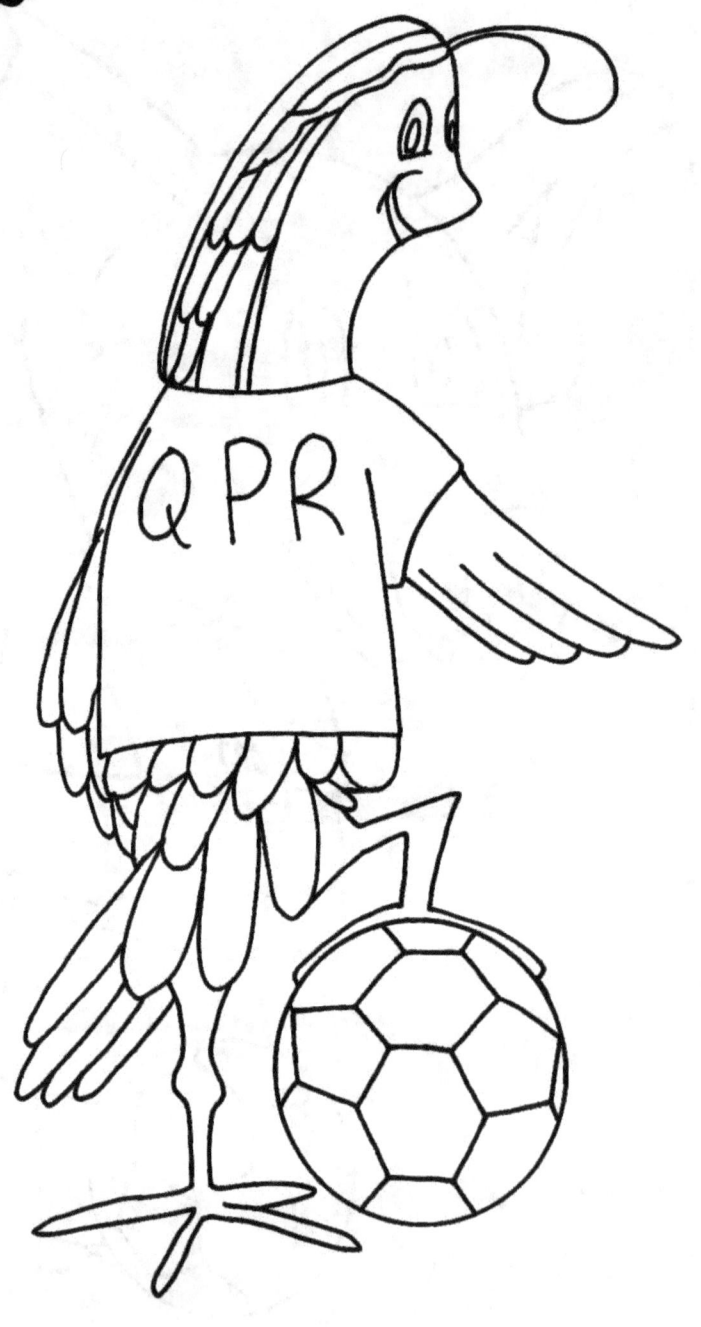

Rabbit

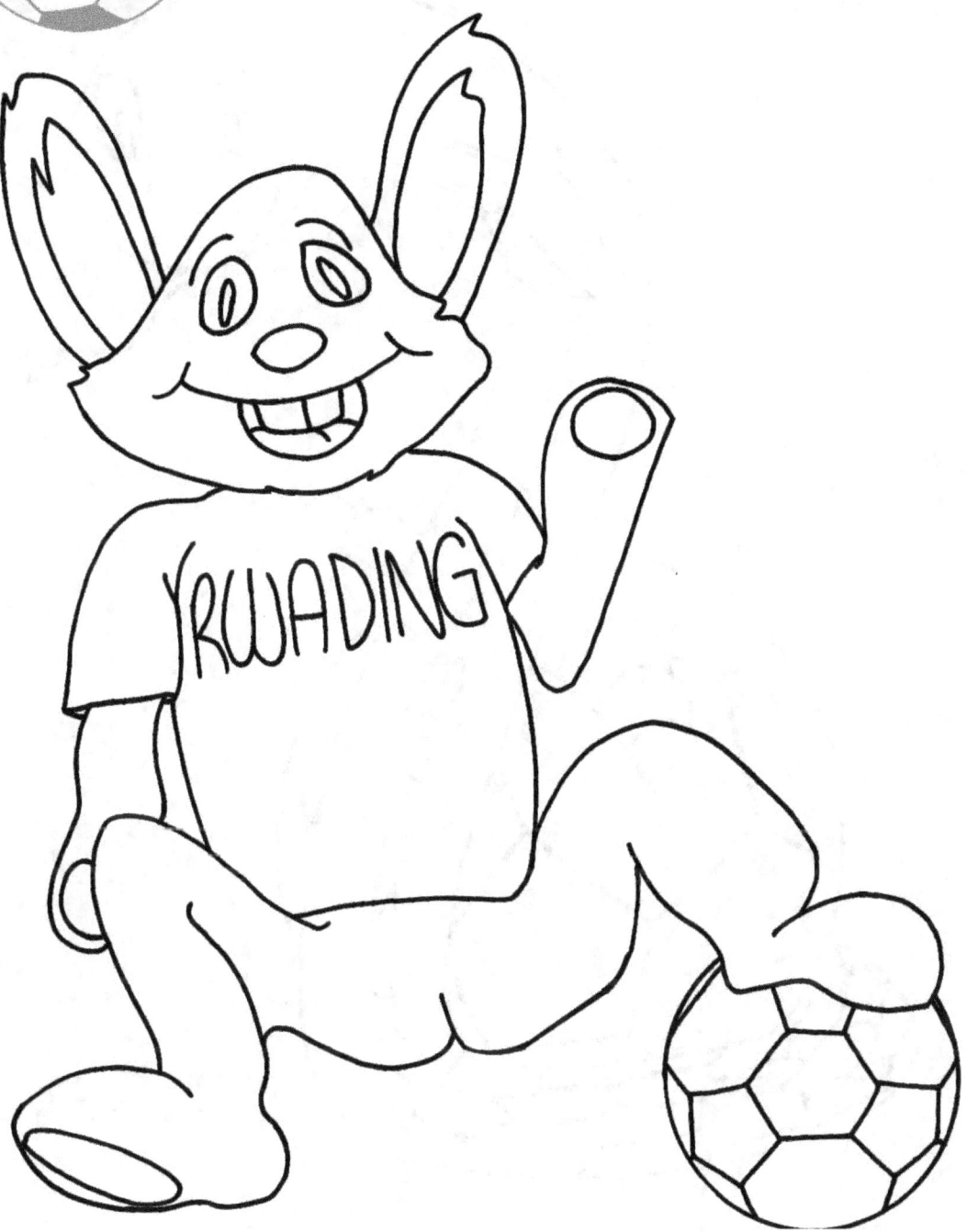

Snake

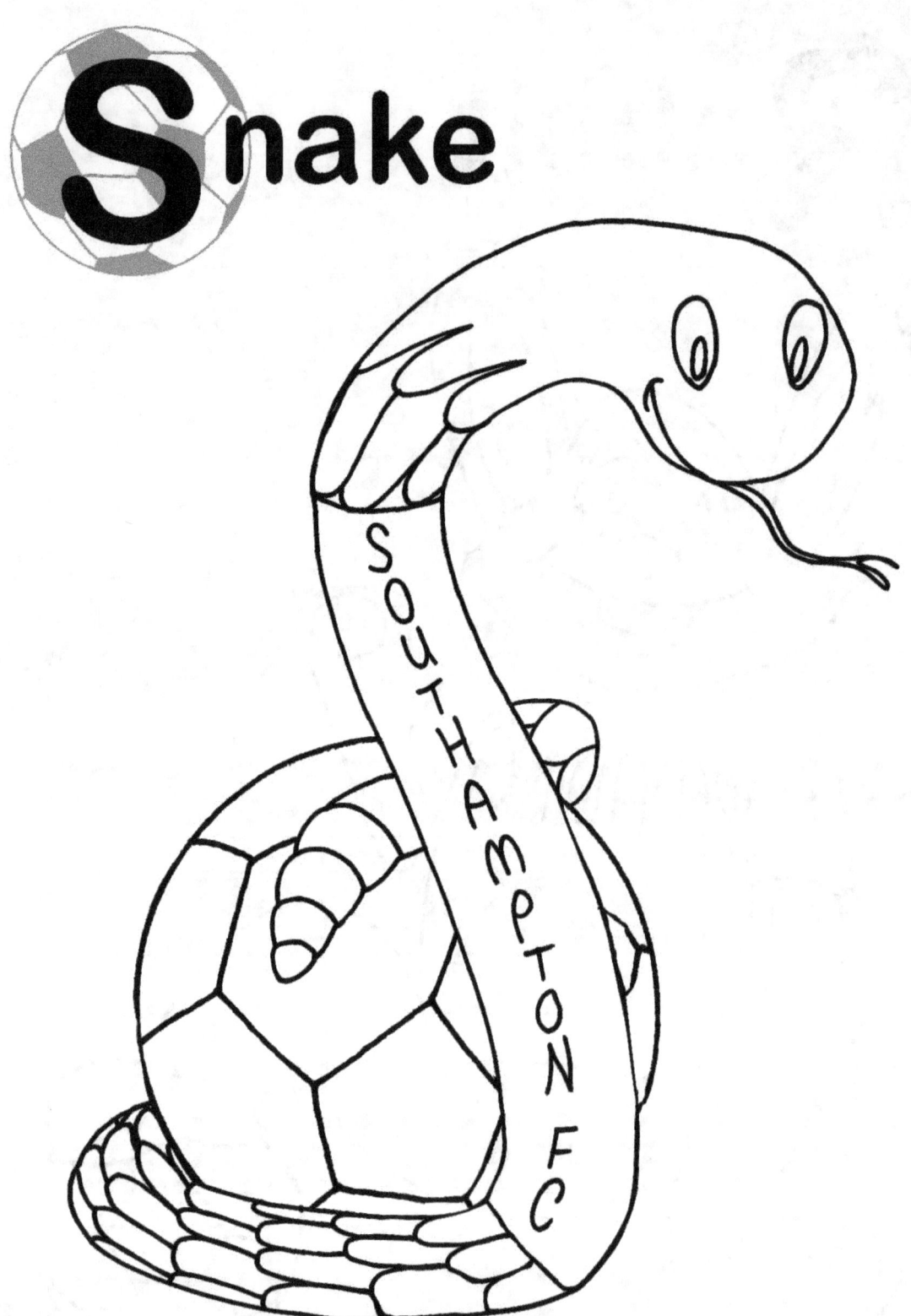

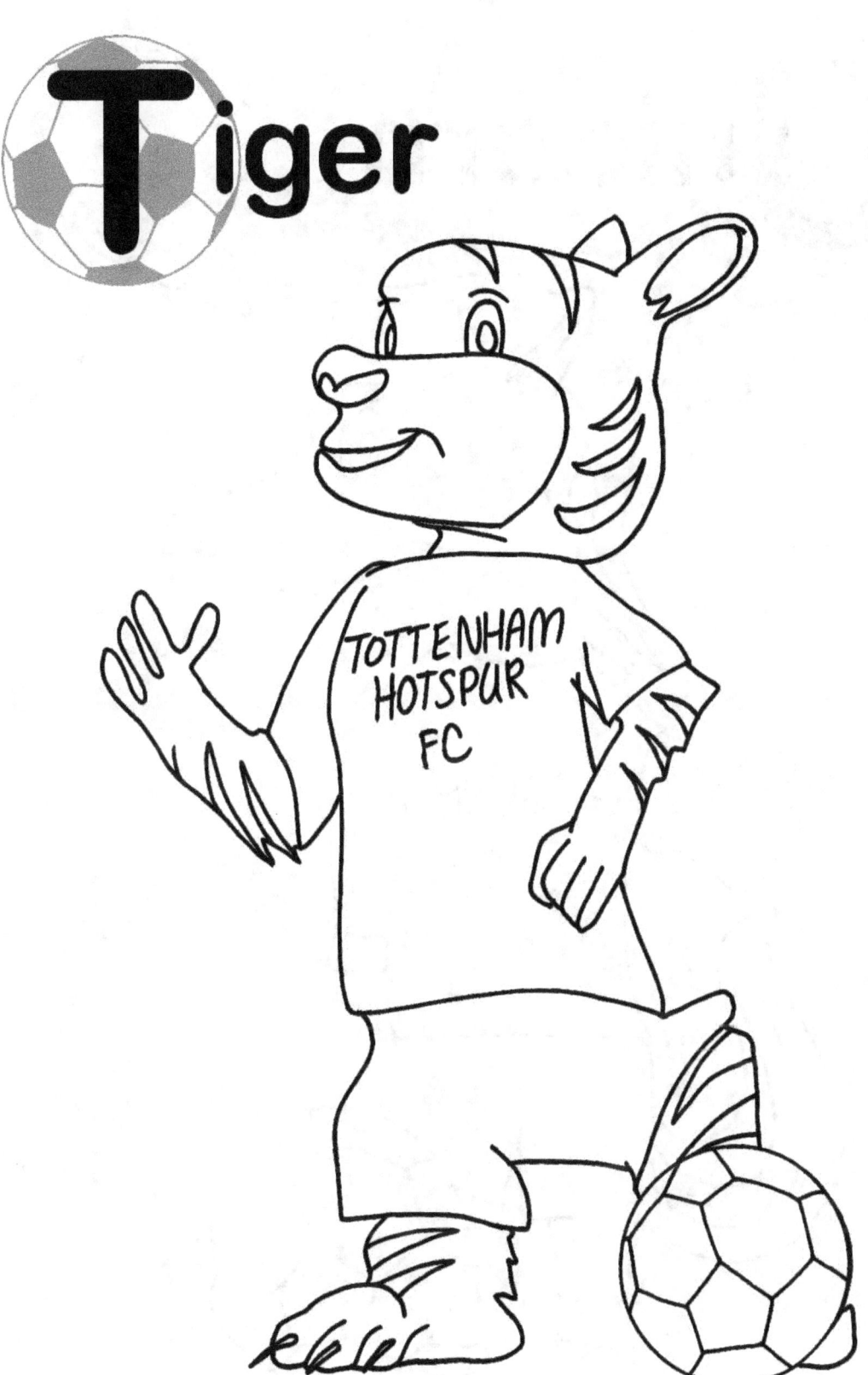

Vampire Bat

Whale

X-ray Tetra

Yak

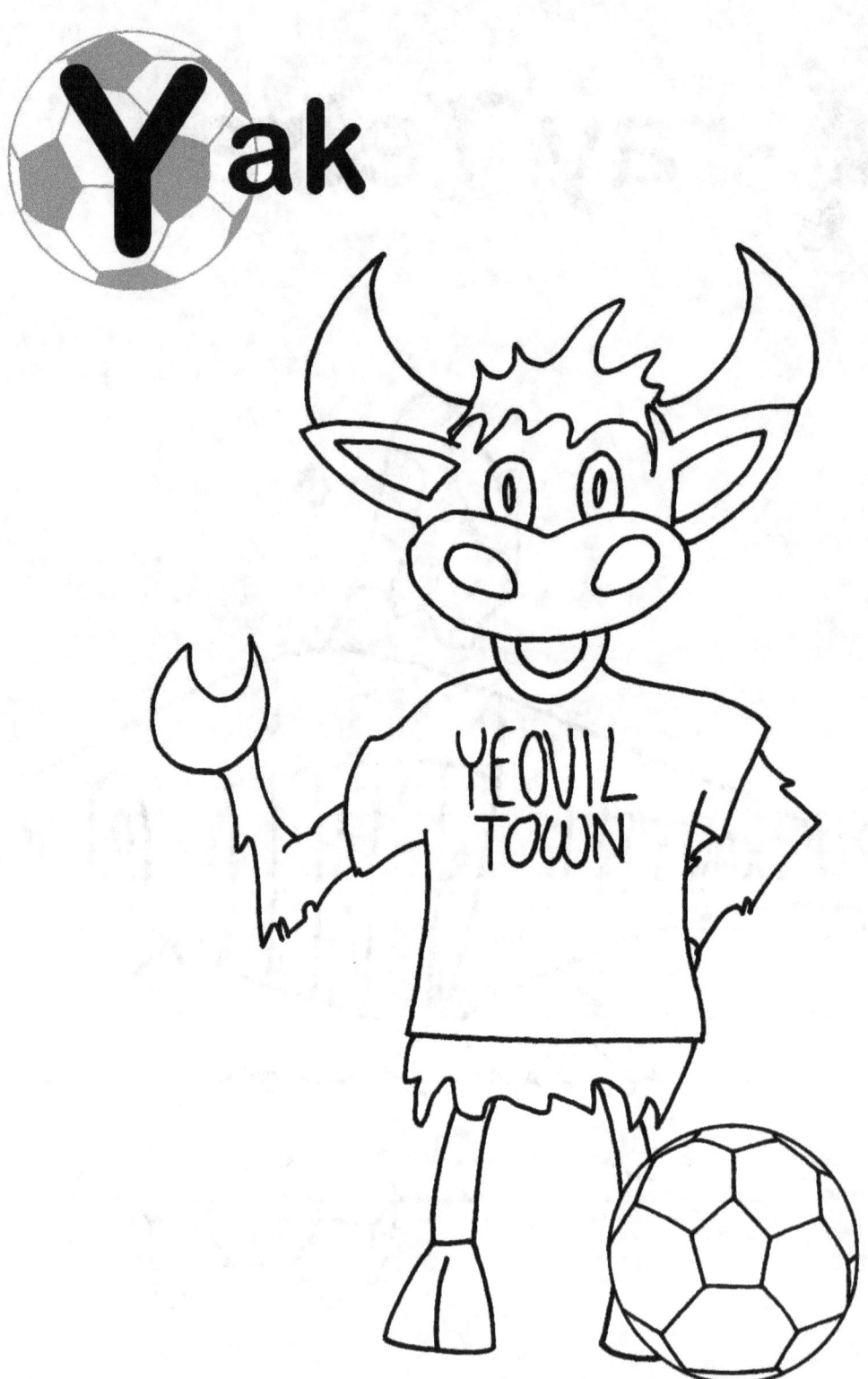

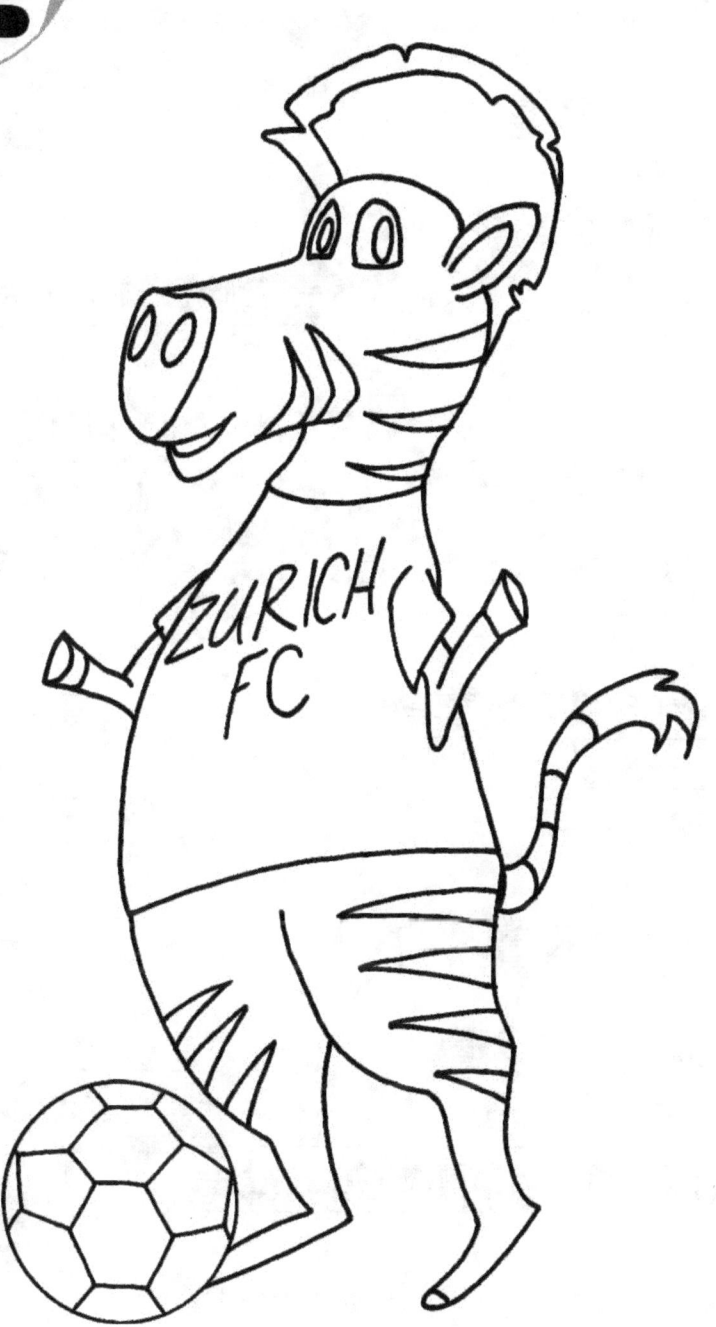

- ARSENAL FC
- BRIGHTON & HOVE FC
- CHELSEA
- DONCASTER
- EVERTOM FC
- FLEETWOOD
- GILLINGHAM
- HUDDERSFIELD TOWN FC
- IPSWICH TOWN
- JUVENTUS
- KILLMANOCK
- LIVERPOOL FC
- MANCHESTER UNITED FC
- NEWCASTLE UNITED FC
- OXFORD UNITED
- PORTSMOUTH
- QPR
- RWADING
- SOUTHAMPTON FC
- TOTTENHAM HOTSPUR FC
- UDINESE
- VALENCIA
- WESTHAM FC
- XANTHI
- YEOVIL TOWN
- ZURICH FC

www.ingramcontent.com/pod-product-compliance
Lightning Source LLC
Chambersburg PA
CBHW081624220526
45468CB00010B/3015